IDEAS THAT SHAPED THE WORLD:

an introduction to the
John Murray Archive

IDEAS THAT SHAPED THE WORLD:

an introduction to the
John Murray Archive

Editor: David McClay
Contributors: Emma Faragher, Lauren Forbes, Danile Gray and Stephen Rigden

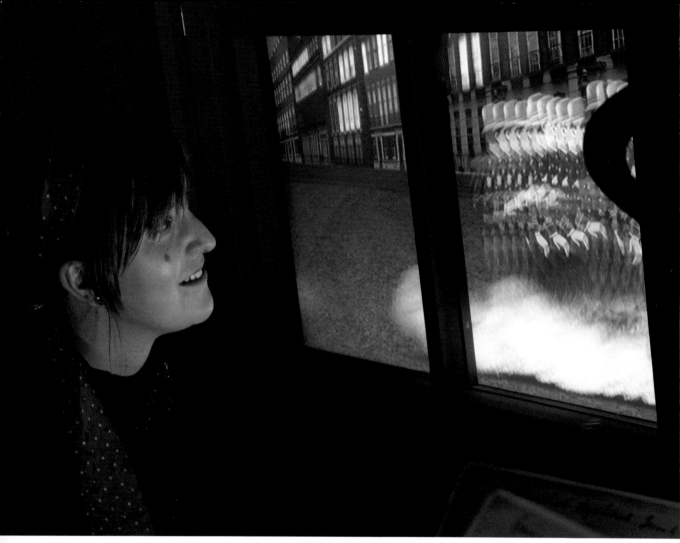

Visitors to the John Murray Archive exhibition at NLS get unique insights into the changing landscape of the world outside the windows of the firm's offices in Albemarle Street, London.

107527

© **National Library of Scotland**

First published in 2007 by
National Library of Scotland
George IV Bridge
Edinburgh EH1 1EW

ISBN: 978-1-872116-30-3

British Library Cataloguing in Publication Data

A CIP catalogue record for this book is available
from the British Library.

Text: David McClay
Design: Matthew Wilson
Photography: Torquil Cramer

Production: Bonnie Murray
Reprographics: Asia Graphic Printing Ltd
Printing: Potts Printers

Contents

Foreword

'My Murray,' was Lord Byron's simple description of John Murray, his publisher. He might well have added a couple of his later lines: 'The Arbiter of others' fate/ A suppliant for his own.'

'My Murray' was not only a publisher of genius, whose list of authors included many of the great names of the 18th and 19th centuries, but the creator, also, of an archive which takes us on a fabulous journey through the literary history of the age, introducing us to the intimate correspondence of writers, poets, explorers and statesmen, while reminding us along the way that publishers then, as now, worry about such mundane matters as sales and advances, missed deadlines and hostile reviews.

When we talk of John Murray, we talk of a dynasty: from the Edinburgh-born John Murray who set up his business in London in 1768 and published the English Review and the works of Benjamin D'Israeli, to his son John Murray who made Byron famous and introduced us to Jane Austen, to the third generation John Murray who risked the wrath of the religious world by bringing out Darwin's Origin of Species, to the fourth John Murray who edited Gibbon and began publication of the letters of Queen Victoria …

But you get the picture. Here, at the National Library of Scotland, concealed within these volumes and boxes, is the story, not only of a publishing house, but of a family which nurtured talent, encouraged ideas, became the recipients of intimate secrets, and dealt, along the way, with the dramas of its authors' lives. To turn the pages of these letters or to lay your hands on the manuscript of an epic poem, is to take part in a creative adventure which should excite, not only the academic and the researcher, but anyone who is interested in the way that books are conceived, written, and finally introduced to the world outside.

Byron himself said, on the publication of Childe Harold: 'I awoke one morning and found myself famous.' To welcome the John Murray Archive back to the city where its story began 220 years ago, is to share a sense of pride, pleasure and astonishment that is positively Byronic.

Magnus Linklater

1

Introduction
David McClay

The first John Murray established his publishing house in Fleet Street, London in 1768. Despite having no previous publishing or bookselling experience he was confident of success, noting that 'Many Blockheads in the Trade are making fortunes' and he saw no reason why he should not 'succeed as well as these'. The publishing house he established spanned seven generations and four centuries. During that time each generation published some of the greatest thinkers and writers of their day, names that resonate still, such as Darwin, Byron, Austen, and Livingstone.

Left: Fleet Street, London.
Above: The founding John Murray.

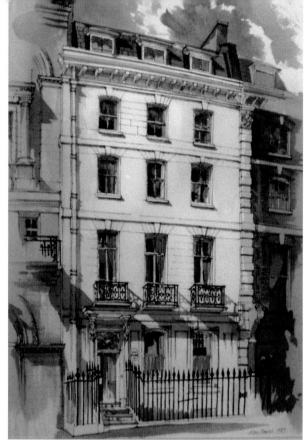

Top left: John Murray II, who published Byron.
Above: The home of the firm in London's Albemarle Steret.

Some of Murrays greatest successes are little known today. Maria Rundell, the most famous cookery writer of her day, sold hundreds of thousands of her book *Domestic Cookery* and made Murray a fortune, although the archive papers reveal a ruined friendship over financial arguments and legal disputes.

In addition to publishing the individual works of authors, the house of Murray was also responsible for great series of works. These included the *Quarterly Review* and *Murray's Handbooks for Travellers*.

The *Quarterly Review* was founded in 1809 in political opposition to the *Edinburgh Review*; it sought to review literary, political and other works. Until it ceased in 1967 it attracted a dazzling array of contributors and reviewers. This publication and the supporting archive papers offer a rare opportunity to explore in remarkable detail the influence and debate of criticism and review over 150 years.

Murray's Handbooks for Travellers were begun in 1836 by John Murray III who, after his own experience of travelling on the Continent, began producing innovative travel guides. At a time when domestic and foreign travel was opening up, the guides came to cover the whole of Britain, the Continent and further afield. Writers and contributors to these guides included known and unknown correspondents, including Thomas Cook

correcting details about the Nile steamers, John Ruskin on Italian hotels, and Felix Mendelssohn, who recommended a hotel where he lived 'with a party of several ladies'.

The legacy of the Murray firm is not confined to its tens of thousands of publications. With great care, each generation preserved in the company archives a remarkable collection of business papers, manuscripts and letters running to hundreds of thousands of items. Through these records you the reader can not only trace the whole publication and creative process, but connect directly with the lives and personalities of the writers. Reading the variously witty, tragic, gossipy but always engaging letters, offers a unique connection to people from centuries past as they are brought back to vibrant life.

" Many Blockheads in the Trade are making fortunes

– John Murray I

The John Murray Archive is swelled by the papers of the late eighteenth-century Edinburgh bookseller Charles Elliot and the nineteenth- and twentieth-century papers of the London publisher Smith, Elder and Co. The latter published many exciting authors of the first rank, including Sir Arthur Conan Doyle, Mrs Gaskell and the Brontë sisters. The Archive also contains the personal papers of Lord Byron – an unparalleled collection of papers that present in detail not just the poetry and publications of the great poet, but his often controversial and never dull life of love and adventure.

With tens of thousands of publications and thousands of authors represented in the John Murray Archive there are an almost unlimited number of stories to be discovered and told. Some of the greatest men and women from our past can be found there: individuals whose ideas helped shape the modern world. There are also a multitude of lesser-known characters from the past, who but for the John Murray Archive may have completely faded from history and memory. They, too, have their story to tell.

The lives and passions of those who dared challenge social and political injustice, inventors and dreamers who changed our world, intrepid travellers into the unknown or storytellers who created such enduring characters and tales – all are to be discovered in the Archive. Each has the potential to help us connect to the past, understand the present and inspire us for the future.

This short book introduces just a few of these personalities from the John Murray Archive and provides an insight into how these papers offer a unique and entertaining understanding of the past.

Science
Lauren Forbes

Science, in all its different disciplines, made great progress during the 19th century. Despite science becoming increasingly specialised and formalised, scientific development and debate continued to involve a range of different disciplines and scientists, making a growing impact on society in general. It was through Murray's publications that the most recent discoveries, theories and inventions were promoted and shared between both scientists and the wider public. Murray published many scientific works of national and international significance, most notably in the fields of astronomy, botany, chemistry, and geology. Amongst these books was arguably the greatest scientific work of the 19th century: Charles Darwin's *On the Origin of Species*. Tracing the story of its publication and reception through the Archive, we see the wider connections between scientists, their specialisms and the increasing influence of science on contemporary life.

OF THE

L O G A R I T H M

OF THE

NATURAL NUMBERS,

FROM

1 to 108000.

BY

CHARLES BABBAGE, Esq., M.A.,

Lucasian Professor of Mathematics in the University of Cambridge,

F. R. S. L. AND E. HON. M R.I.A. F. R. A. S. F. C. P. S.
ET ACAD. BRUX. SOC. CORR., SOC. PHILOMATH. PAR. SOC. CORR., ACAD. LION SOC., ACAD. MARS.
SOC. PHYS. ET HIST. NAT. GEN. SOC. BON., IMP. ET REG. ACAD. MOD.,
IMP. ET REG. ACAD. GEORGOF. FLORENT., ACAD. LYNC. ROM., IMP. ET REG. ACAD. HAFNIÆ. SOC.
ET REG. ACAD. NEAP. SOC. CORR., REG. ACAD. HAFNIÆ. SOC.
ET REG. ACAD. MONAC. SOCIUS CORR., &c.

STEREOTYPED.—SECOND EDITION.

LONDON:

PRINTED FOR B. FELLOWES, LUDGATE STREET.

1831.

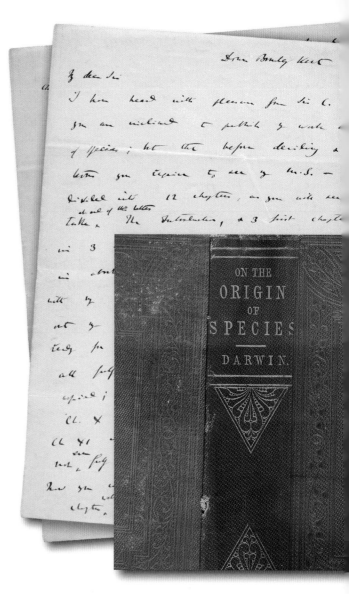

Charles Darwin

Murray published all of Charles Darwin's many works, of which *On the Origin of Species* is the most famous. The theories of evolution put forward in this work had an impact not just on a range of scientific fields but on religion and wider society as well.

In one letter of 1859 Darwin advised Murray that 'it is the result of more than 20 years' work …. The book ought to be popular with a large body of scientific & semi-scientific readers, as it bears on agriculture & history of our domestic productions & on the whole field of Zoology, Botany and Geology. I have done my best, but whether it will succeed I cannot say. I have been quite surprised at finding how much interested strangers & acquaintances have become on the subject.'

"I have done my best, but whether it will succeed I cannot say. I have been quite surprised at finding how much interested strangers & acquaintances have become on the subject.

– Charles Darwin

> **"I have heard with pleasure from Sir C. Lyell that you are inclined to publish my work on the Origin of Species …**
>
> **– Charles Darwin**

In addition to the details of the production, publication and distribution of Darwin's works revealed through the company's business papers and Darwin's own letters, the John Murray Archive contains letters from a range of people who wrote either to support or reject his theories. One of these is the Reverend Whitwell Elwin, to whom Murray had sent the manuscript of *On the Origin of Species*. He wrote to Murray:

'upon the subject of Mr Darwin's work on the Origin of Species. After you had the kindness to allow me to read the Ms. [manuscript] I made a point of seeing Sir C Lyell, who I understood had in some degree, advised the publication. I had myself formed a strong opinion the other way …'. He continued, 'It seemed to me that to put forth the theory without the evidence would do grievous injustice to his views & to his twenty years of observation & experiment. At every page I was tantalised by the absence of the proofs. All kinds of objections & possibilities rose up in my mind …'.

Geologists

Geology was one of the most popular and controversial scientific subjects of the 19th century.

Murray published many of the greatest (and often contradictory) geological works, including Sir Charles Lyell's *Principles of Geology*, along with books from Robert Murchison, William Buckland and Jean Louis Agassiz. Lyell was influential in advising Murray to publish Darwin's *On the Origin of Species*, but Murray also published works (including an anonymous pamphlet of his own) which attacked or cast doubt on Darwin's geological claims, for example those of Agassiz, who wrote of Darwin's theories 'I trust to outlive this mania.'

Astronomers

Murray published and corresponded with Sir John Herschel, one of the greatest astronomers of his day and founder-member of the Astronomical Society. As editor of the *Admiralty Manual of Scientific Enquiry*, Herschel often wrote to Murray. In one agitated letter of 1849 he wrote:

'Mr Darwin has pointed out to me a mistake of the composition … in the manual so very gross as to convert the most important part of his paper into utter nonsense'.

©Hulton Archive/Getty Images

Astronomy became a 'hobby' for James Nasmyth (right), the mechanical engineer, once he retired from industry in 1856. Designing and making his own telescopes, he observed the moon and the sun, and developed his own technique to provide images, photographing detailed models – an example of this is included among his letters in the archive. His letters also reveal a keen sense of humour. Writing to thank Murray for payment for his book *The Moon considered as a Planet, a World and a Satellite*, he says: 'I am glad to know that our moon continues to send forth such £.s.d rays'.

Botanists

Arguably the most distinguished botanists of the 19th century were Sir William Hooker and his son Sir Joseph Hooker, who became the first and second full-time directors of Kew Gardens. Included with Sir William's letters is a certificate of thanks to Murray from the Royal Botanic Gardens, Kew, for the contribution of 'a packet of seeds of the Cedar of Lebanon which are <u>very</u> acceptable to the Arboretum'.

Joseph Hooker was a friend and supporter of Charles Darwin, as his letters in the Archive reveal; like his letter to Murray dated 1860 which criticises an 'ignorant, intemperate reviewer' of *On the Origin of Species*. In earlier letters he tells Murray of his travels in Europe and recommends sleeping on trains as a time-saving measure. He had also approached Murray with parts of his Indian journal in 1853, seeking publication. Aware of the mark of quality the Murray name would confer on his work, he wondered 'whether a work of such a kind would merit your countenance – which would be a guarantee to the public of its good performance that I should very much desire'.

Chemists

The great chemist Sir Humphry Davy, remembered today as the inventor of a safety lamp for miners, wrote to Murray near the end of his life; weakened by a stroke, Davy sought recovery travelling in Italy with his brother John. He wrote to Murray about his book on an abiding interest, *Salmonia, or, Days of Fly-Fishing*, saying 'I continue very weak; but I hope recovery from travelling and mental repose'. In 1829, after further ill-health, Davy delegated his letter-writing to his brother John, who, following

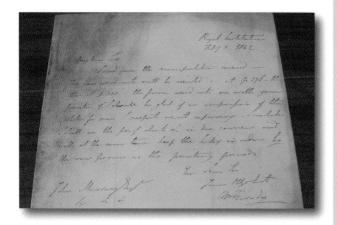

Davy's death, writes concerning Davy's posthumously published *Consolations in Travel, or, The last days of a Philosopher*. Davy's last letters and this final work offer a great insight not only into science but also into the life and wisdom of one of the first professional men of science.

Davy was to be overshadowed by his one-time apprentice and protégé Michael Faraday. Murray published a number of Faraday's works, including *Chemical Manipulation*.

Murray created a network of his many scientific writers, often circulating copies of their recent works among them; for example, Faraday writes to Murray:

'I am exceedingly obliged by your kindness in sending me Mr Darwin's remarkable book ... I shall read it with great attention'.

Queen of Science

When Mary Somerville died in 1872 at the age of 92, she was known as the Queen of Science. Despite only a year's formal education and the disapproval of her father, she taught herself algebra and

Scientist Mary Somerville is just one of the first eleven characters to feature in the JMA exhibition.

geometry and became interested in a wide range of scientific fields. Her scientific and mathematic books were immensely influential, helping to popularise science and bring it to a wider audience. Her enthusiasm and passion for science never waned, as a letter to Murray in 1871, written at the age of 91, reveals: 'I thank you very sincerely for your valuable gift of Darwin which interests me exceedingly'. She also describes updating her latest work *On Molecular and Microscopic Science* for a possible second edition to take account of recent developments and, although she admits that prolonged reading tires her, her mind is as sharp as ever: 'I am happy to say I have not lost my facility in mathematics'.

Her letters to John Murray and to some of the greatest scientists of the day are not restricted to the topics of publishing and science. Engaging and chatty, the letters mention the weather, the health and activities of friends and family as well as gossip and scandal, as the following example from 1857 illustrates: 'I have just heard news that has surprised

Mary Somerville

science and natural religion, *The Ninth Bridgewater Treatise*; his criticism of the Great Exhibition of 1851; his works on logarithms, his work on political economy; *On the Economy of Machinery and Manufactures*; along with papers on geology. However, it is for his pioneering work with his difference engine and calculating engine, precursor to modern computers, that he is best known.

In an 1834 letter to Murray, an exasperated Babbage complains of the sheer number of visitors wanting to see his Calculating Engine: 'My Dear Sir, I find myself obliged daily to restrict myself more closely in allowing the Calculating Engine to be seen, you have hardly any idea of the time consumed <u>even</u> in refusals'. To cope with the numbers, he restricted visits 'to persons who are really well acquainted with mathematics and mechanics', but warns that he is currently so busy that even such serious scholars will have to wait.

With all his interests and the pressure on his time, it is no wonder that he sometimes sought solace in nature and became distracted, as one delightful letter shows: 'My visit to Wimbledon was but short and in my search after the picturesque in the Park I got sight of your house from too far a point to be able to reach it'. Perhaps only a hard-pressed mathematician could explain a missed visit to his publisher in quite that way.

The Murrays published in all the fields of 19th century science, some works had a greater impact than others, but all had a role to play in the development of the modern world.

us not a little. Sir David Brewster 76 years old was married a few days ago to Miss Parnell aged 26 a grocer's daughter. Sir David and his daughter have been living at Cannes which he left a few days before the wedding without saying a word to his daughter of his engagement'.

Charles Babbage

At a time when scientists could and did work in more than one discipline, Charles Babbage still stands out as remarkable. After studying mathematics at Cambridge University he lectured and wrote on many subjects. In his letters he discusses a remarkable variety of topics, including his philosophical work on

Babbage's calculating engine, the precursor to the modern computer.

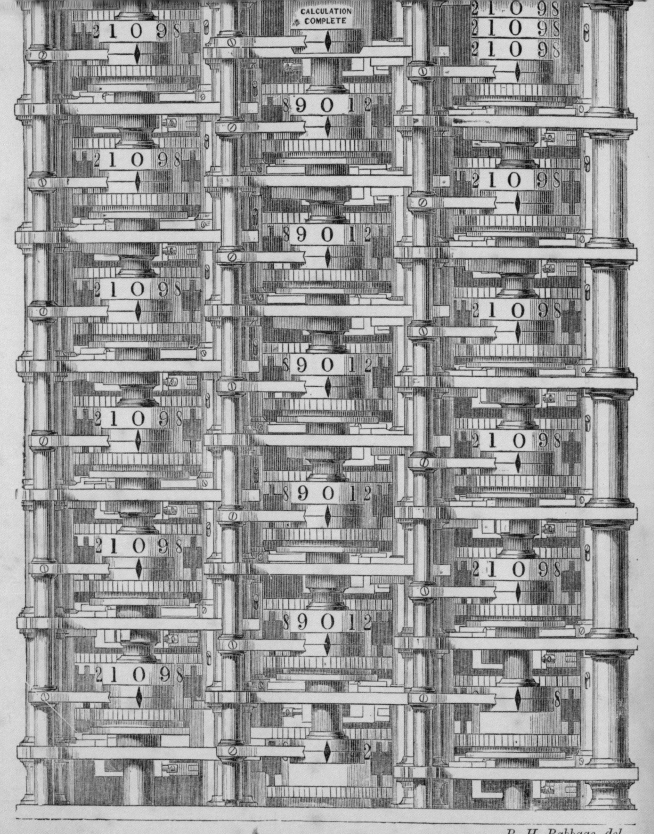

CALCULATION
COMPLETE

B. H. Babbage, del.

3
Travel and Exploration
Stephen Rigden

The 19th century was one of the great eras of exploration and travel, and the publishers of the age were only too willing to provide accounts of the latest voyages and journeys to an enquiring readership. The Murrays, with the acute awareness of public interest that was to ensure their long success, met that interest handsomely.

John Murray II and John Murray III attracted an extraordinary list of authors on exploration, travel and tour. Among them were many of the foremost explorers and travellers of the period; whether naturalists, geographers, diplomats, archaeologists or people who simply desired adventure. The John Murray Archive contains not only the business papers and records for their books, but for many, including David Livingstone, Sir Austen Henry Layard, Sir John Barrow, Paul du Chaillu and Isabella Bird Bishop, their personal letters and manuscripts as well.

John Murray III was particularly interested in exploration and travel. He was not, however, concerned only with those who had adventured in earnest, but also in those with more modest journeys to make – the general traveller. He devised a series of very successful travel guides – *Murray's Handbooks for Travellers* – to assist in planning and making journeys on the Continent, and throughout Britain (the firm was later to include more distant places – Syria, India, New Zealand and Japan – among the titles of the handbooks).

Isabella Bird Bishop

On 26 May 1855 the travel writer John Milford composed a short letter to John Murray III; it concerned a young lady. The letter began:

'I have the pleasure of introducing to you Miss Isabella Bird', and continued, 'I have but a slight acquaintance with her myself, but I met her at the Bishop of Winchesters [sic] … She has recently returned from a tour of a few months in Canada and other parts of N. America and is about to submit the results of her travels to the public. I have according to her request given her a letter to you, as she wishes to submit her mss [manuscript] to your inspection.'

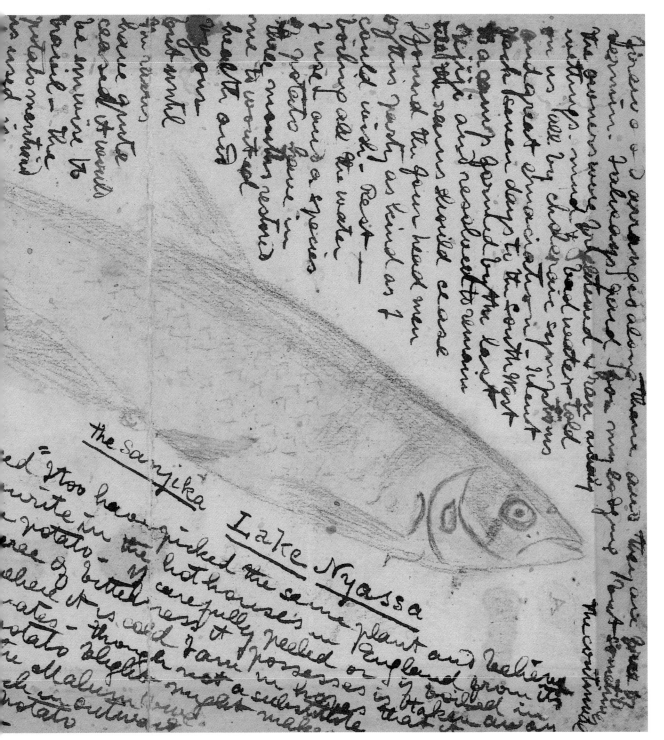

David Livingstone's journal drawing of a fish found at Lake Nyassa, Africa.

©Hulton Archive/Getty Images

dutifully, were not universally admired – Sir Austen Henry Layard commented intemperately on 'these women who unsex themselves and do what no refined or modest woman would do' – but Murray was not without encouragement for them. Milford's letter helped to achieve Isabella's purpose and her first book, *The Englishwoman in America*, was published by Murray in 1856.

Isabella's association with Murray was to last the remainder of her life. The firm published all of her many works.

Between 1854 and her death in 1901 Isabella travelled widely and adventurously, establishing herself as one of the most remarkable women travellers. She became so redoubtable a traveller that

Poor Milford! One has the sense that Isabella cornered him at one of the Bishop's luncheons – the more so for his observation that she 'appears clever and energetic'.

The introduction made, as requested, the rest of the letter concerned the writer Richard Ford – except for the postscript, which Milford used to add an interesting comment: 'Miss Bird is the daughter of a clergyman in Huntingdonshire and travelled in Canada chiefly alone'. Might not the 'clever' Isabella have suggested such an addition? If the narrative of the wanderings, 'made chiefly alone', through Canada and North America by a 24-year-old spinster daughter of a clergyman were not to be worth the consideration of a publisher, what would have been?

Adventurous women travellers, as distinct from those who accompanied their husbands abroad

she was made a fellow of the Scottish Geographical Society in 1891, and the first woman fellow of the Royal Geographical Society in 1892.

The Archive contains an important series of Isabella's letters to John Murray and also to her beloved sister Henrietta, whom she addresses as 'My own dear pet'. The letters – often of considerable length – give full and informative details of various stages of her travels. In addition the Archive contains a fine series of photographs from some of her journeys.

Publishing adventure

The John Murray Archive includes an important collection of the papers of Sir Austen Henry Layard. Layard led a remarkable life – adventurer; diplomat; politician; journalist; art historian – but he first came to public attention through his archaeological excavations of the palaces of ancient Assyria.

Layard's extensive digs between 1845 and 1851 resulted not only in the enrichment of the collections of the British Museum and other great institutions, but in two classic publications of adventure: *Nineveh and its remains* and *Discoveries in the ruins of Nineveh and Babylon*. Murray published both.

Many of the working papers for these publications are held in the Archive, allowing us to consider Layard in the guise of the published author. We can follow the publication process from the manuscripts to the proofs, note Layard's own editing of the proofs and see how the manuscripts were changed sometimes subtly, but at other times thoroughly, to achieve strength and clarity. Trial printings of illustrations are included, many of which had to be accurate representations of archaeological finds; and we see the challenges for the printers in setting cuneiform type and general

Proof sheet of Austen Layard's Nineveh and its Remains.

layout. There are also the ledgers and other business books in which the costs of production are recorded.

By stages we are able see how the barely legible manuscripts (in the polite language of the palaeographer, Layard's handwriting would be described as 'a difficult hand') were transformed into the fine, richly illustrated works that do full justice to Layard's exciting narratives, evoking so

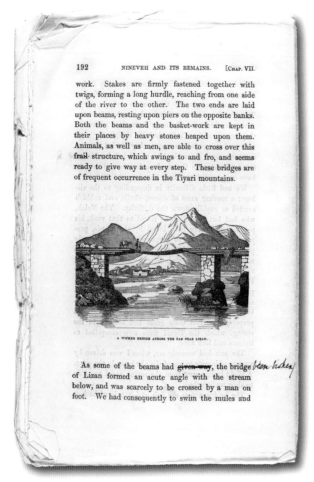

192 NINEVEH AND ITS REMAINS. [Chap. VII.

work. Stakes are firmly fastened together with twigs, forming a long hurdle, reaching from one side of the river to the other. The two ends are laid upon beams, resting upon piers on the opposite banks. Both the beams and the basket-work are kept in their places by heavy stones heaped upon them. Animals, as well as men, are able to cross over this frail structure, which swings to and fro, and seems ready to give way at every step. These bridges are of frequent occurrence in the Tiyari mountains.

A WICKER BRIDGE ACROSS THE ZAB NEAR LIZAN.

As some of the beams had given way, the bridge of Lizan formed an acute angle with the stream below, and was scarcely to be crossed by a man on foot. We had consequently to swim the mules and

well the exoticism and adventure of the lands that beguiled him.

The pleasure of a well written and well produced book is such that it is all too easy to be ignorant, or forgetful, of the great task of writing and publishing work. Publishers' archives remind us of that demanding process.

Murray's Handbooks for Travellers
'Travelling made easy'

John Murray III, unlike his father or his grandfather, had been able to travel for leisure in early manhood. Murray made the first of his journeys to the Continent in 1829 at a time 'not only before a single railway had been begun, but while North Germany was yet ignorant of Macadam'. He travelled with the blessing of his 'very indulgent father'– with one sensible condition: that he prepared himself by mastering the language of the country he was to travel through. The Archive includes the two extant volumes of his very readable letters written from the Continent to his family during his travels of 1833 and 1836.

The difficulty of travelling in Europe without a published guide, having only local knowledge to rely on, inspired Murray to devise his famous series of travel guides – *Murray's Handbooks for Travellers*. Murray was an observant man, and reading the descriptions in his letters it is simple to understand how his experiences led him to formulate his handbooks.

From inception onwards, Murray's involvement with the handbooks was wholehearted: he even wrote the first *Handbook for Travellers on the Continent*, published in 1836. Subsequently, as the popularity of the handbooks increased with the number of possible destinations, Murray commissioned other authors to meet the demand. Some of the works, such as the *Murray Handbook for Spain*, by Richard Ford, are exemplars of the kind.

Such was the success and influence of the handbooks that GS Hillard noted in 1855 that 'Murray's Guidebooks now cover nearly the whole of the Continent and constitute one of the great powers of Europe. Since Napoleon no man's empire has been so wide. From St. Petersburg to Seville, from Ostend to Constantinople, there is not an inn-keeper who does not turn pale at the name of Murray'.

The detail in the handbooks was quite remarkable, to the extent that trying to keep them current was a significant undertaking. At the start Murray relied upon a circle of friends to try the handbooks, and to report any defects. Subsequently he included a notice at the front of the works encouraging the user to note any errors or omissions, and to send them to 'Mr. Murray, Albermarle Street'.

Later handbooks included clear maps for the benefit of the traveller – in particular, fine colour maps provided by the Edinburgh publisher John Bartholomew and Co. The association between John Murray and John Bartholomew continues to this day at the National Library of Scotland, where the archives of both publishers are held.

The successful format of the handbooks led to imitators; most famously the German publisher Karl Baedeker. In 1874 Sir George Osborn wrote to Murray referring to the increase in the number of Baedeker's works. He commented scathingly, 'I take the liberty to inform you that I was very much concerned to see how that most flagitious pirate Baedeker is flooding every nook and corner of the continent with his guide book'. He added, 'I well know that his book is compiled and borrowed from yours, and that he is unjustly seeking to reap what you have sown'.

That Baedeker's name became synonymous with travel handbooks is true; but John Murray III was the man who was 'the author, inventor, and originator of a class of works which … may be said to have had no little influence in producing the result of "Travelling made easy"'.

> "I take the liberty to inform you that I was very much concerned to see how that most flagitious pirate Baedeker is flooding every nook and corner of the continent with his guide book.
>
> – Sir George Osborn

Literature

Rachel Thomas

For most of the 19th century the Murrays did not concentrate on publishing poetry or prose, distrusting these fields of literature as volatile and risky. How much more remarkable it is then that their roster of authors include some of the greatest names in 19th-century literature: Lord Byron, Sir Walter Scott, James Hogg, Felicia Hemans, Robert Southey, Washington Irving and Jane Austen, to name just a few. The 20th century was equally rich, particularly after the takeover of the publisher Smith, Elder and Co., with great authors including Sir Arthur Conan Doyle, William Makepeace Thackeray, Charlotte Brontë, George Eliot, Elizabeth Gaskell, Anthony Trollope and John Betjeman on their books.

113

Emma

A Novel in 3 Volumes

by Author of Pride & Prejudice

at 21/. Subscrib'd at 14/9

50

50

18

6

19

let her change the lot —

but is Earth more fair?

what to make one admired —
all things love
were mighty

Thraldom again be

in enlightened man
days

his virid chains — Soft he

him lowly gaze —

no more before you

20 —

If not — were one fallen tyrant boast no more —
the guiding fair
chains were furrowed with hot tears
her Purple flowers long wiped up before

one's publisher'. Murray was proved correct; it was an instant and enduring success, and Byron happily noted of its popularity that 'I awoke one morning and found myself famous'.

Byron was also one of the most controversial characters of his age, whose exploits scandalised society. Both aspects, life and work, are wonderfully documented in the Archive.

Amongst his many manuscripts are parts of his most famous epic poems *Childe Harold's Pilgrimage*

Byron

John Murray II was involved, at his Albemarle Street address, with the burning of Lord Byron's controversial memoirs. Fortunately a great deal of the letters, manuscripts and papers of Byron and his circle survive, with over 10,000 items in the John Murray Archive.

Byron was one of the most popular poets of his day, selling over 100,000 copies of his poems. The first collaboration between poet and publisher was Byron's epic poem *Childe Harold's Pilgrimage*. Despite Murray's confidence, Byron had some doubts over its chance of success, including concerns over the format of the book which he thought 'a cursed unsaleable size', but he conceded that 'one must obey

Manuscript of Byron's Childe Harold's Pilgrimage, canto III.

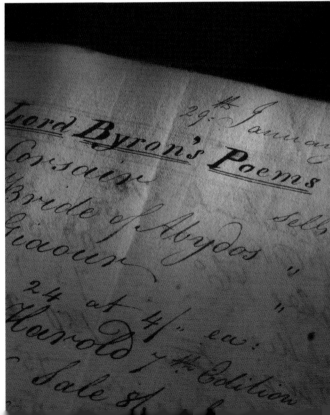

and *Don Juan*. His often chaotic and wild scribbling, with scored-out alterations and criss-cross writing, connect the reader to the moment these great works of English literature were born upon the page. Mary Shelley copied out many of Byron's manuscripts for him, but discovered this to be no easy task, as she found his handwriting so difficult to decipher.

The intimate and personal letters to and from Byron are a captivating read. They include those from one of his many lovers, Lady Caroline Lamb. A poet and author in her own right, she had a brief affair with Byron in 1812. It was she who, after breaking off their relationship, famously described him as 'mad, bad and dangerous to know'. Her many letters to Byron and John Murray, and her commonplace books, reveal a love-struck and broken-hearted woman. In a letter to Byron in 1812 she begins 'This comes from one that suffers, When you open this … you will be as far from me in distance as you are now in heart', and continues, 'though men can forget, women do not'. Her love for Byron never ceased and many years later she still yearned for knowledge of him. In one letter of 1820 to Murray she queries false reports that Byron had returned from the Continent to England:

'you have never written to tell me about him now did you know the pain & agony this has given me

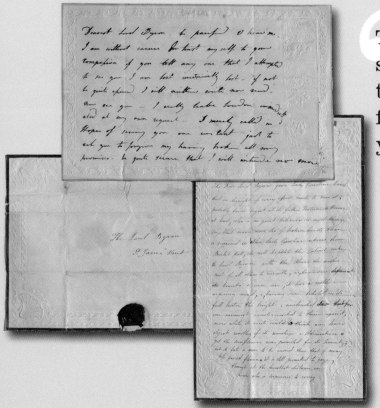

" This comes from one that suffers, When you open this … you will be as far from me in distance as you are now in heart.

– Lady Caroline Lamb [to Byron]

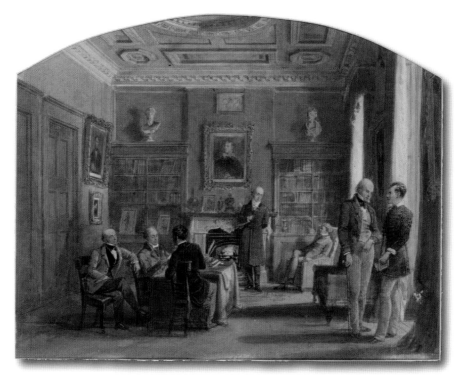

Murray's '4'oclock friends' at Albemarle Street.

you had not been so remiss … [tell] me how he looks what he says, if he is grown fat if he is no uglier than he used to be if he is good-humoured or cross-grained putting his brows down – if his hair curls or is straight … if you had the smallest <u>tact</u> or aught else you would have written long ago.'

There are also many letters from Byron's friends, including Percy Shelley, Mary Shelley, John Cam Hobhouse and Leigh Hunt. In one of these letters a recently married Mary Shelly wrote: 'Another incident has also occurred which will surprise you, perhaps; It is a little piece of egotism in me to mention it – but it allows me to sign myself – in assuring you of my esteem & sincere friendship, Mary W. Shelley'. In the same letter she informs him of the birth of his illegitimate daughter, Allegra, by Clair Clairmont.

When Allegra died just a few years later it was to Murray that Byron wrote:

'You will regret to hear that I have received intelligence of the death of my daughter Allegra of a fever … It is a heavy blow for many reasons, but must be borne, with time … It is my present intention to send her remains to England for sepulture in Harrow church (where I once hoped to have laid my own) and this is my reason for troubling you with this notice … Would you have any objection to give the proper directions on its arrival.'

Just one of the many examples of the deep level of trust and friendship that existed between the two men, a relationship that went beyond that of publisher and author.

Washington Irving manuscript

Abbotsford

I sit down to perform my promise of giving
an account of a visit made many years
[sin]ce to Abbotsford: I hope, however, that you
[will] not expect much from me, for the travelling
[no]tes taken at the time are so scanty and
[v]ague, and my memory so extremely fallacious,
that I fear I shall disappoint you with the
and crudeness
meagreness of my details.

Late in the evening of the 29th August
[1]816, I arrived at the ancient
[l]ittle border town of Selkirk, where I put up
[fo]r the night. I had come down from
Edinburgh *partly to*
visit Melrose Abbey and its vicinity,
— but chiefly to get a sight of the
minstrel
mighty of the north." I had a
[l]etter of introduction to him from Thomas
[C]ampbell the poet, and had reason to think
[fr]om the interest he had taken in some of
[m]y earlier scribblings, that a visit from

Washington Irving

Many international authors were published by Murray, including the American Washington Irving, whose famous short stories *The Legend of Sleepy Hollow* and *Rip Van Winkle* remain popular today. Murray also published Irving's other works of fiction, history, travel and social commentary.

Washington Irving copyright aggreement.

The manuscript for one of these works, *Abbotsford and Newstead Abbey*, recounts Irving's visits to Sir Walter Scott's and Lord Byron's houses. His visit to Abbotsford was the start of a lasting friendship, and it was through Scott that Irving was introduced to Murray. The voluminous correspondence between Irving and Murray, whom he regarded as the 'Prince of Booksellers', reveals not only a long and successful business partnership but a deep mutual respect and friendship, which both treasured.

> "The dinner, therefore, would have been little better than tolerable, had it not been remarkable for the confession of Sir Walter Scott that he was the author of the Waverley Novels.
>
> – John Murray III

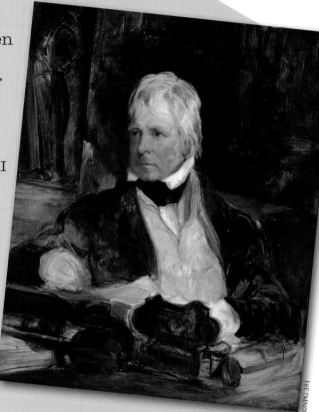

The John Murray Archive contains a short autobiography of Irving. This was intended only for Murray's own use, as the accompanying letter made clear: 'They are for your private use and I trust no undue publicity will be given to them'. The reason for sending this was to assist in some legal disputes between Murray and other publishers over Irving's nationality, of which he noted 'I above all I have no idea of compromising my character as a native-born and thoroughly loyal American citizen'.

Sir Walter Scott

Murray was first introduced to Scott when he bought a quarter-share in the publication of Scott's work *Marmion: A Tale of Flodden Field*. Such was the financial success of this work that Murray was able to use his share of the copyright as partial security for his purchase of fashionable premises in Albemarle Street.

Scott was a central figure in the history of the publishing firm. He was often found at the Murrays' elegant drawing room at Albemarle Street, particularly at 4 o'clock, when Murray's authors, men of literature, science, travel and politics, would meet together to enjoy one another's company and discuss the issues and publications of the day. It was here that Scott first met Byron, following a reconciliation brokered by Murray. They became friends and admirers of each other's work and the Archive contains a copy of a moving eulogy on Byron composed by Scott.

Scott was one of the main forces behind the establishment of Murray's *Quarterly Review* and contributed many articles to it, including reviews of Robert Burns, Lord Byron's *Childe Harold's Pilgrimage*, and Jane Austen's *Emma*; he even, rather harshly, anonymously reviewed his own work, *Tales of a Grandfather*, which had been published pseudonymously under the name Jebediah Cleisbotham.

In 1827 John Murray III, whilst studying in Edinburgh, wrote to his father of a dinner he had attended in which Sir Walter Scott was accidentally declared the author of his, previously, anonymous novels:

> 'The dinner, therefore, would have been little better than tolerable, had it not been remarkable for the confession of Sir Walter Scott that he was the author of the Waverley Novels. Sir Walter rose, and said, "I did not expect on coming here today that I should have to disclose before 300 people a secret which, considering it had already been made known to about thirty persons, had been tolerably well kept. I am not prepared to give my reasons for preserving it a secret, caprice had certainly a great share in the matter. Now that it is out, I beg leave to observe that I am sole and undivided author of those novels." … This declaration was received with loud and long applause.'

Jane Austen letter and sales subscription entries.

Jane Austen

Jane Austen is one of the most famous fiction writers of the Regency period. Her novels – *Pride and Prejudice, Sense and Sensibility, Persuasion, Emma, Mansfield Park*, and *Northanger Abbey* – are popular not just with modern readers but known to many television, film and theatre audiences as well.

However Jane Austen was not nearly as well known in her own day, and did not profit as much from her literary writings as other Murray authors. As the Murray ledgers and papers show, she earned less than £700 in her lifetime, compared to Lord Byron, who made around £20,000.

Austen dealt directly and firmly with Murray, taking a close interest in the progress of each of her publications, extending to the costs of printing and paper, the copyrights and reprint editions. Austen described Murray as 'a Rogue of course, but a civil one'.

Murray persuaded Austen to overcome her reluctance to dedicate *Emma* to the Prince Regent,

the future George IV, whom she did not particularly care for. The Murray ledgers reveal that she was responsible for the cost of providing a handsomely bound copy to the Prince, but her letters show she was not above using the Prince's name to speed up delays at the printers:

> 'I am so very much disappointed & vexed by the delays of the Printers that I cannot help begging to know whether there is no hope of their being quickened …. Is it likely that the Printers will be influenced to greater Dispatch & Punctuality by knowing that the Work is to be dedicated, by Permission, to the Prince Regent?—If you can make that circumstance operate, I shall be very glad.'

> "a class of fictions which has arisen almost in our own times …

– Sir Walter Scott [on *Emma*]

The success of *Emma* was helped by an anonymous review by Sir Walter Scott in Murray's *Quarterly Review* in which he praised it as being of 'a class of fictions which has arisen almost in our own times, and which draws the characters and incidents introduced more immediately from the current of ordinary life than was permitted by the former rules of the novel'.

5

Politics and Society

Daniel Gray

The birth and growth of the Murray publishing firm spanned a political and social era that saw Britain go through a period of rapid and widespread change. Agrarian was replaced by industrial, nation state by Empire, and the long march to the emancipation of women and the working-class began.

Portrait of Benjamin Disraeli.

Mr Dent will meet with
every consideration

Murray faithfull
S Smiles

J Murray

The Murrays' involvement in all of this was, unsurprisingly, significant. Though always latent, the firm's interest in politics manifested itself outwardly with the 1809 launch of the *Quarterly Review* journal, a Tory response to the Whig *Edinburgh Review*. From then onwards, Murray correspondents and authors included prime ministers such as Robert Peel, Benjamin Disraeli and WE Gladstone.

Also courted were key economists and social theorists such as Thomas Malthus and Samuel Smiles. In 1859, John Murray III published Smiles' seminal work *Self-Help*. Released on the same day as Charles Darwin's *Origin of the Species*, it was to have a marked effect on political and social life, just as Darwin's work had on the scientific landscape. Arguing that people from the lower orders of society could achieve economic and social comfort through rigorous self-improvement and hard work,

the book sold 20,000 copies in its first year, and over 200,000 by the end of the century. *Self-Help* was also translated into over 40 languages and enjoyed international success as far a field as Japan and South America.

Smiles was not the only radical (or at least, one-time radical – he had previously advocated the Chartist cause) who came into contact with the Murray firm. Showing an openness which characterised much of their decision-making, the conservative Murrays corresponded with the likes of Robert Owen, William Wilberforce, Thomas Erskine (the radical lawyer who represented Thomas Paine), the anarchist William Godwin, Millicent Garrett Fawcett and John Stuart Mill.

This willingness to engage with and publish a plethora of differing ideas was undoubtedly a contributory factor in the house of Murray's success. Through this diversity the firm not only reflected society, but also shaped it.

[Handwritten letter:]

> Hawarden
> Jan 19. 48
>
> My dear Sir
>
> Please to send copies of my Speech on Jewish Disabilities to Rev. William Maskell care of Mr Pickering
> Rev. T. W. Allies
> Rector of Launton
> Oxon
> and I should be much obliged if you could send down to me here the list of the London Committee which Mr Rogers sent to you
> Sincerely yours WE Gladstone
> J. Murray Esq.

Gladstone's Evolution

WE Gladstone, the man Queen Victoria called 'that half-mad firebrand who would soon ruin everything and be a dictator', had a long and prolific relationship with the house of Murray, beginning with the publication in 1841 of his *The State in its Relations with the Church*.

Gladstone, then ultra-conservative MP for Newark, wrote to John Murray II in 1838, offering 'some papers on the subject of the relations of the Church and the State', and humbly asking 'whether Mr M would be inclined to see them, with a view to entering into arrangements for their publication'. Murray duly published a work in which the devoutly Christian Gladstone propounded the idea that as each nation's church was best suited to that nation's interests ('Religious Nationality'), so that church should act as a moral guide to the state ('Religious Responsibility').

The State in its Relations with the Church went through a rigorous editorial process, witnessed in the manuscript of the work, in which the ever-meticulous Gladstone frequently glued on amendments to the text. The John Murray Archive also contains a number of Gladstone's other manuscripts, such as his *Speech on Royal Supremacy* and the hugely revealing *A Chapter of Autobiography*, and in each can be seen this attention to detail, his work on paper reflecting the orderliness he was famed for in life.

Between 1835 and 1898, Gladstone wrote some 300 letters to the three John Murrays who headed the firm over that period. This correspondence centred largely on publishing matters, though was often peppered with political news (on 2 July 1850, Gladstone wrote: 'You will grieve to learn that Sir Robert Peel is dead – within the last half hour. A great man is gone from among us, and a broad, deep void, not easily filled, remains').

> "You will grieve to learn that Sir Robert Peel is dead – within the last half hour. A great man is gone from among us, and a broad, deep void, not easily filled, remains.
>
> – WE Gladstone

A

VOICE

FROM

THE FACTORIES.

In Serious Verse.

DEDICATED TO

THE RIGHT HONOURABLE

Lord VISCOUNT ASHLEY.

The abuses even, of such a business, must be cautiously dealt with; lest, in eradicating them, we shake or disorder the whole fabric. We admit, however, that the case of CHILDREN employed in the Cotton Factories is one of those that call fairly for legislative regulation. M'CULLOCH.

LONDON:
JOHN MURRAY, ALBEMARLE STREET.
MDCCCXXXVI.

The publisher's relationship with Gladstone spanned a fascinating and pivotal era in British society, and in the evolution of the four-time prime minister's political outlook. When he began writing for John Murray II he had recently opposed the abolition of the slave trade; by the time John Murray IV was in charge of the firm, the 'Grand Old Man' had spread the franchise to the working-class and was idolised by millions. Not bad for a 'half-mad firebrand'.

Screaming Eloquently
Caroline Norton – *A Voice from the Factories*

'Are they free who toil until the body's strength gives way?' These words were composed not by Karl Marx, but by a John Murray author writing years before the radical German philosopher rose to prominence.

Caroline Norton was an impassioned and tireless campaigner for the rights of women and children amid a Victorian culture in which neither group fared well. Norton's 1836 extended poem A *Voice from the Factories*, published by Murray with the author left anonymous, embodies her radical ethos. It stands as a clarion call for the immediate abolition of a factory system manned by children working in horrifying conditions. Norton chastises Members of Parliament for their ambivalence towards this exploitation of the young, writing that they

'prostitute their utmost powers of tongue/feebly to justify this great and glaring wrong' in their 'defence of the unalienable right of gain'.

To add further potency to her case, she makes a powerful comparison between the plight of factory children and that of plantation slaves, themselves so recently liberated (the Slavery Abolition Act having been ratified by Parliament in 1833): 'Poor little creatures overtasked and sad, your slavery hath no name – yet is its curse as bad'.

A *Voice from the Factories* seeps with a radicalism so often suppressed in the genteel atmosphere of the Victorian Establishment (Norton, was married, unhappily, to Tory MP George Norton, brother of Lord Grantley). The sentiments therein and the style of poetry, echoed in her other works, too, were what led Henry Nelson Coleridge to call her 'the Byron of our modern poetesses'.

In later years, Norton continued to push forward the cause of women and children and, enraged by her own marital experiences, was instrumental in bringing about the 1839 Infant Custody Bill (giving women the right to keep their children until the age of seven following divorce – children had previously been treated as property of their fathers) and the 1857 Matrimonial Causes Act (allowing divorce through law courts rather than expensive Private Acts of Parliament).

'An Imprudent Act': Benjamin Disraeli, John Murray and *The Representative*

Demonstrating precocity befitting a young man who would later serve as Prime Minister, the 19-year-old Benjamin Disraeli responded to the second John Murray's rejection of his novel *Aylmer Papillon* with a caustic, if affable, jibe. Of his redundant manuscript Disraeli wrote 'the sooner it be put behind the fire, the better', and then continued with the teasing 'as you have some small experience in burning manuscripts, you will be perhaps so kind as to consign it to the flames', a reference to the infamous burning by Murray and his cohorts of Lord Byron's journals. For a budding author responding to a publishing behemoth in 1824, this showed a daring that would propel Disraeli to the top of what he later famously termed 'the greasy pole'. Yet, owing to Murray's longstanding friendship with his father (the author Isaac D'Israeli), and the young Disraeli's verve, they were soon working together, and a life-long relationship between 'Dizzy' and the the Murrays began.

In 1825, Disraeli proposed that he and John Murray set up a Conservative newspaper to rival *The Times*. As he was already considering such a venture, Murray gave his enthusiastic young friend the go-ahead, and *The Representative* was born. Murray was to own (and so be liable for the costs of) half of the enterprise, while Disraeli and his 'city financer' friend

©Photo by Jabez Hughes/Getty Images

Heated letters were sent to the Murrays, with Disraeli writing to Anne Murray (the wife of John Murray II) accusing her husband of 'speaking of me to the world generally in terms which are as inexplicable as they appear to be outrageous'. His mother, Maria D'Israeli wrote to Murray himself: 'googI must resent your late attack on Benjamin … I must not suffer Ben to lay any longer under an odium which can be explained away by the truth being told'.

Parental ire was pacified somewhat when Isaac and Maria came to realise the extent of their son's exploits (he had kept them blissfully unaware of the costs he had contractually promised to bear), and friendly relations between the families eventually resumed.

The house of Murray published many of Disraeli's works, and the man who came to be adored by so many (including Queen Victoria, critic of Disraeli's great rival Gladstone) continued to correspond with the publishing dynasty until 1880. In the charming and concerted manner he persuaded John Murray II to part with vast sums of money for a misadventure John Murray III termed 'one of the few imprudent acts' of his father's life, the young Disraeli showed all the audacity and cunning that was to characterise his incredible career.

Mr Powles would share a quarter each. The future prime minister was dispatched to Edinburgh to seek the help and wisdom of luminaries such as Walter Scott and his son-in-law John Gibson Lockhart. Such manoeuvrings were considered so sensitive that in his letters to Murray from Scotland, Disraeli referred to those he met with in code, explaining: 'from the very delicate nature of the names interested, it will be expedient to adopt some cloak'.

The newspaper was launched on 25 January 1826, with expectancy levels elevated by the involvement of the highly successful Murray brand. Yet at around the same time, Disraeli and Powles disappeared from view, patently unable to pay for their half of the undertaking. Murray had been left in the lurch, and the paper ambled on for several torturous months before, on 27 July 1826, it was officially wound up, with the publisher a then-astronomical £26,000 worse off.

Murray was unsurprisingly angry, but kept his disgruntlement private. However, this secrecy did not stop the D'Israeli family becoming aggrieved at accusations they believed had been levelled by the scorned publisher at his former business partner.

> " I must resent your late attack on Benjamin … I must not suffer Ben to lay any longer under an odium which can be explained away by the truth being told.
>
> – Maria D'Israeli [to John Murray]

very delicate natures of names interested,
it will be expedient to adopt some
cloak —

Sir W. S

<u>The Chevalier</u> will speak for itself.

<u>M</u> — from Melrose — for Mr L —ockhart

X for a certain personage on whom we
called one day — who lives a slight
distance from town, and who was
then unwell —

Canning

O For the political Puck —

<u>Mr Chronometer</u> will speak for itself, at
least to all those who give African
dinners —

I. M Barrow?

I think this necessary; & try to remember
it — I am quite delighted with Edinburg — its
beauties become every moment more
apparent — The view from the Calton Hill find
me a frequent votary —

In the present state of affairs

The Archive at NLS

When the John Murray Archive came to the National Library of Scotland in 2006 it found a welcome and appropriate home. It joined a national collection which includes not only the thousands of Murray publications, but the archives and papers of the numerous publishers they worked with and the personal papers of many of their authors, such as James Hogg, Sir Walter Scott and David Livingstone.

John Murray III.

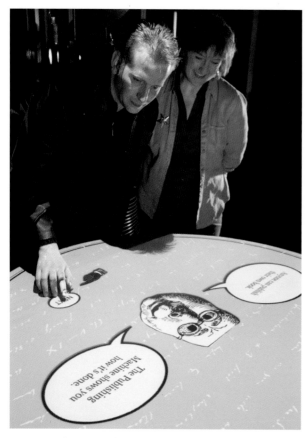

Interactive features at the exhibition challenge visitors to test their publishing nous.

A broad programme of exhibitions, talks, web features and events produced by the Library will tell the story of John Murray and of publishing, highlighting fascinating characters from the collection. Along with some individuals who may be old friends, new characters will also be introduced. Whoever interests and inspires you – the great men and women of poetry and prose, scientists, politicians, travellers and explorers – all, from archaeologists to zoologists, are part of the John Murray story and have their own stories to share.

The Archive and other collections are available to consult at the National Library of Scotland. As a user of the Library you can see and hold these iconic items of our past and browse through boxes of papers that perhaps only a few have read since they were penned generations ago. Who knows what you might discover?

The John Murray Archive has the power to educate, to entertain and to inspire. Connecting with the great publications of the past, many are struck with the relevance and ease by which they can understand and engage with the challenges, excitement and personalities of the time. These people, their lives, are not so different from our own: the passion of political debate, the fear and exhilaration of travel into the unknown, the pace of innovation and change, the romance or escapism of a riveting story. All this and more is waiting to be discovered amongst the archives of one of the worlds greatest ever publishers. This is your collection, your history and heritage; you are welcome to explore.

> " The John Murray Archive has the power to educate, to entertain and to inspire.